Primrose and the Violet T

Amy Watson

To order additional copies of this book, contact:
Xlibris
844-714-8691
www.Xlibris.com
Orders@Xlibris.com

ISBN: Softcover 978-1-6698-1105-3
 Hardcover 978-1-6698-1106-0
 EBook 978-1-6698-1104-6

Print information available on the last page

Rev. date: 02/25/2022

Primrose and the Violet

3/24/16, 9:40 p.m.—Walked 30 minutes. Tonight I drew the left side of the face including the nose, the lips, and the chin. I arrived late and had to unpack my supplies for my new project. Then I had to arrange the room appropriately. Signed name on "Love" painting.

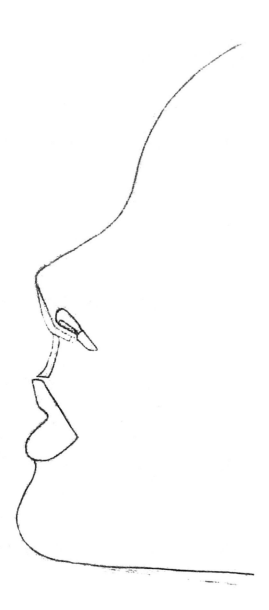

3/25/16, 9:40 p.m.—Walked 30 minutes. Tonight I created the outline for the left side of the face. I filled in the lips with detail. I created the nostril with shading. I began the eyelashes.

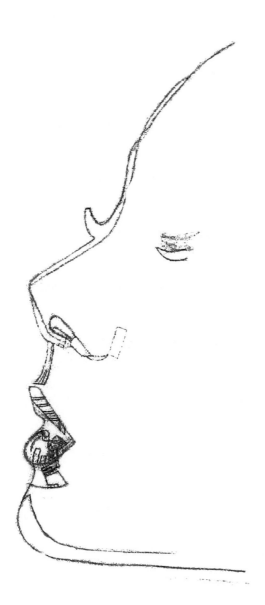

3/26/16, 9:50 p.m.—Walked 30 minutes. Tonight I created the detail in the eye stemming from the eyelash. I started the eyebrow. I began the shading from one eye to the next. I shaded on the chin and underneath. I began on finger and nail continuing with the shading inside as well as the outline. I drew a line for the arm.

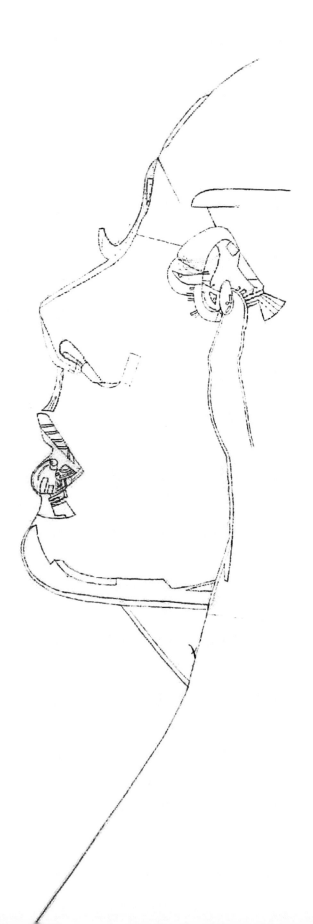

3/29/16, 4:40 p.m.—Walked for 30 minutes. Did a lot of shading on the face. I added shading above the nose. I completed the eyebrow with shading. I created the ring with shading and began the next finger. I got an early start today. I ate peach oatmeal for lunch.

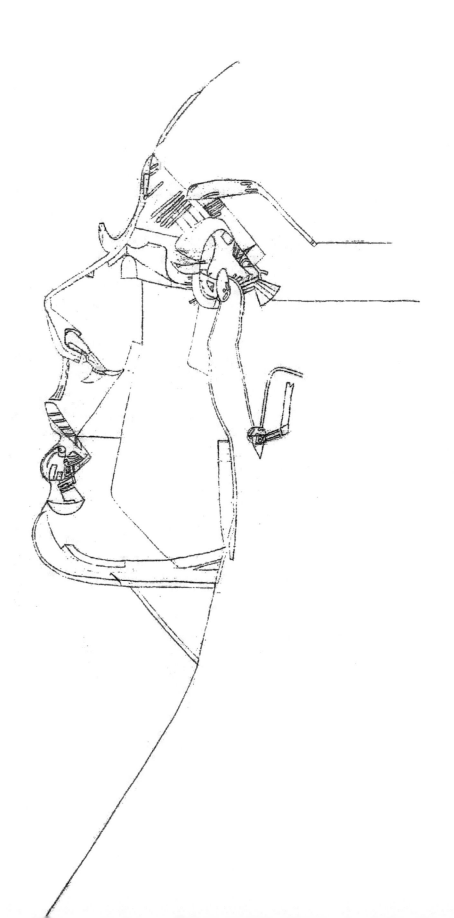

3/30/16, 5:50 p.m.—Walked for 30 minutes. Finished two fingers and outlined them. I also shaded them. I began the thumb. I had some trouble with the pointer finger looking like one. I also created the shading for the ring finger. The hand might be too small. There is more than enough room for the hat, as well as the shirt, arm, and lipstick. Everything else should be easier.

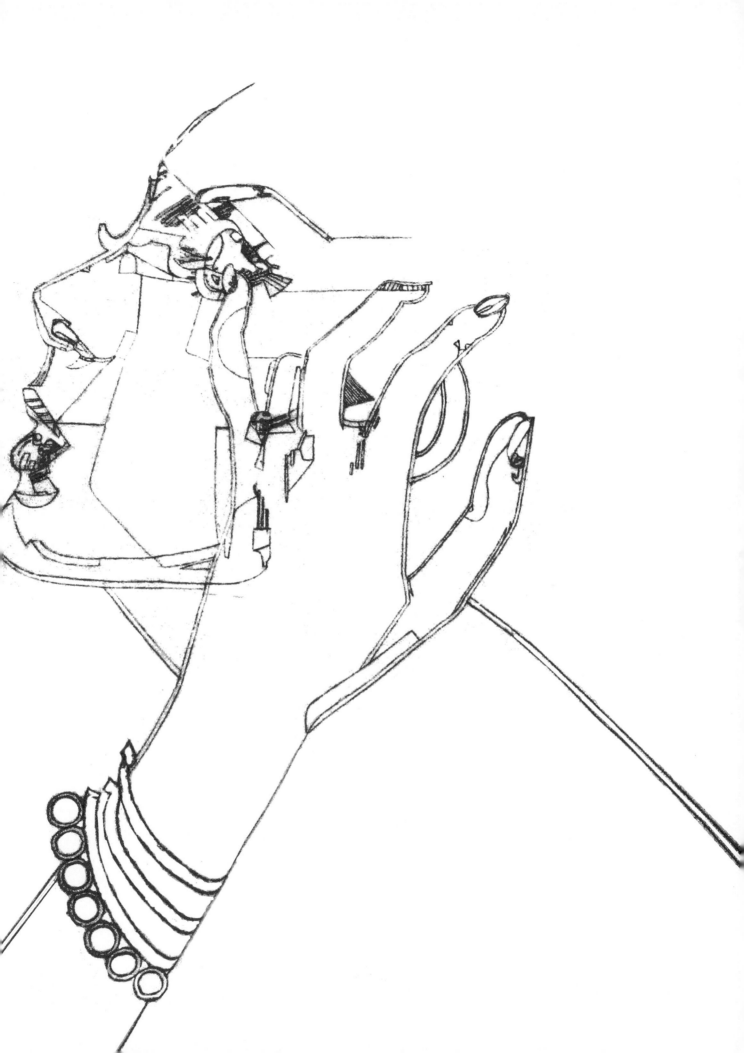

3/31/16, 6:45 p.m.—Walked for 30 minutes. Got to a late start because I had to go to the dentist. I finished the thumb and added shading. I created the ear. I created the arm and added bracelets. Because the one with the pearls ran off the page, I had to be creative. I created the shoulder and extended it, since it ran off the page. Now I will have some meat with my boyfriend.

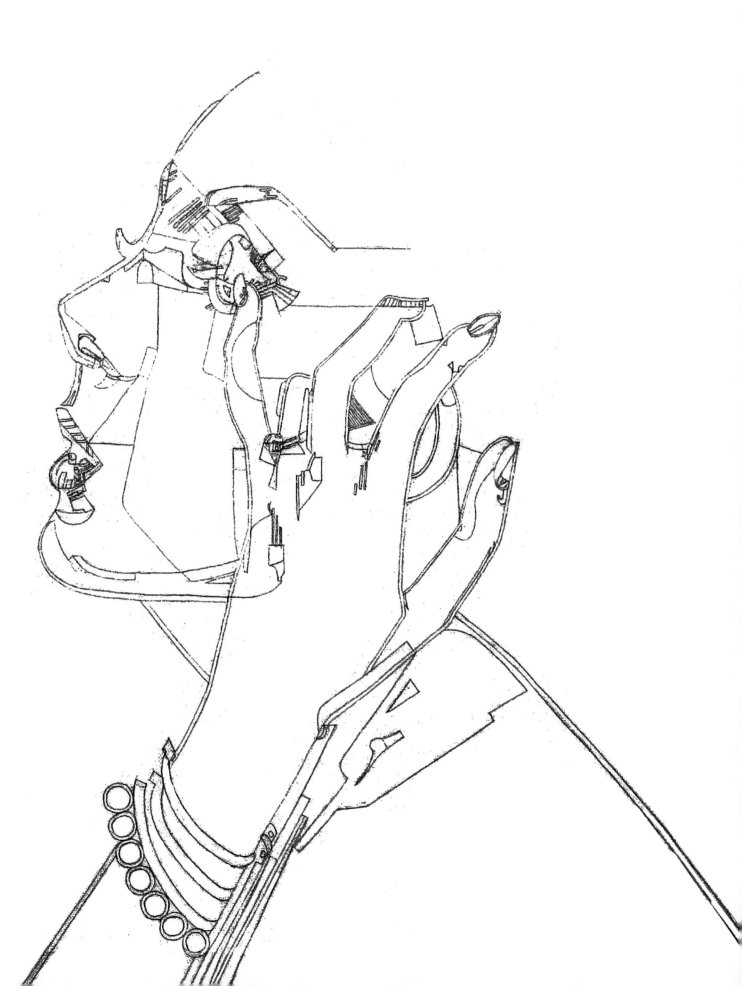

4/6/16, 6:50 p.m.—Walked for 30 minutes. I created the shading underneath the arm and on the shoulder. I also began the shading in between the fingers and on the ear. I got a late start today, because I had to run some errands with my boyfriend. I brought some more supplies like paint brushes and paint. I'm having a difficult time finding the right color. I had some nuts and a fruit roll up.

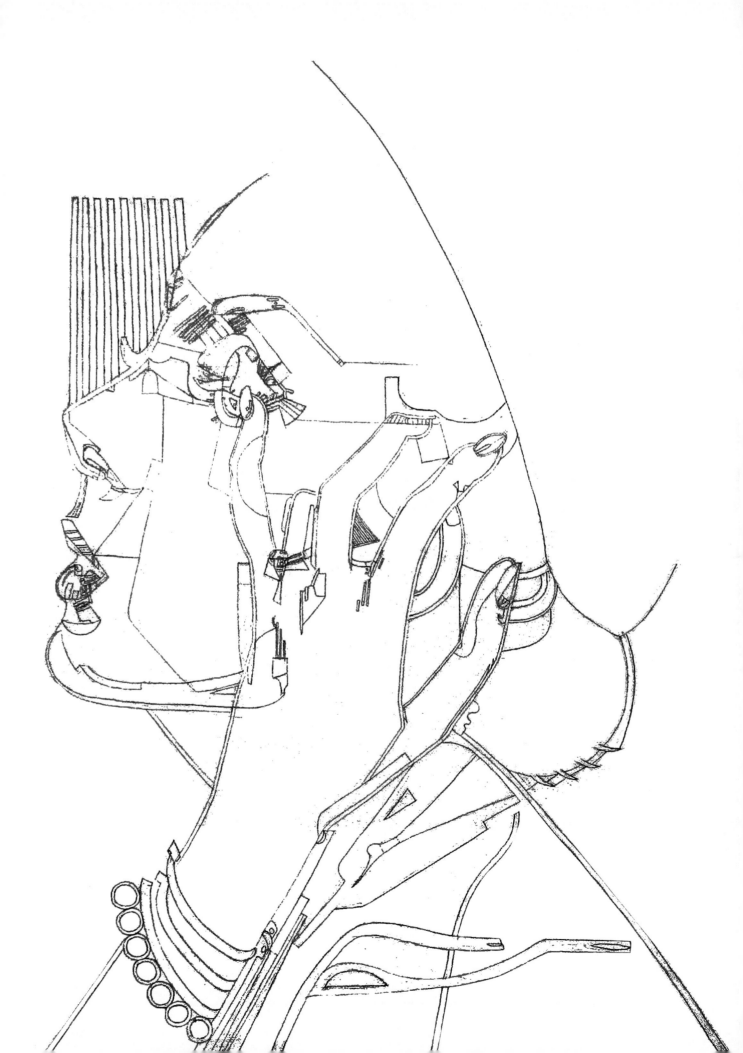

4/7/16, 9:33 p.m.-I drew the creases in the shirt. I also drew the shapes in the hair to shade. I drew the outline of the hair with the strands peaking out. I created the bottom of the hat with an outline I drew horizontal lines near the eye lash which is the shading for the hat. I came later today because I had a doctor's appointment. I ate nuts and a fruit roll up again. I had many coffees. When it became late, I had decafe. I was very giggy tonight.

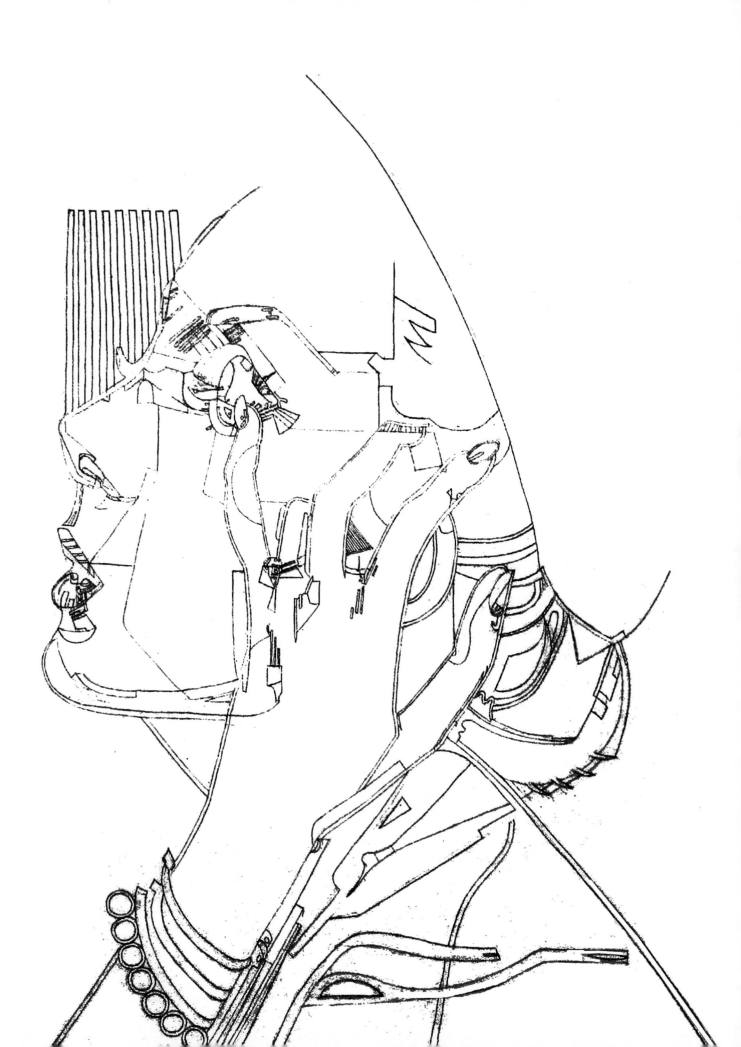

4/8/16, 8:10 p.m.–Walked for 30 minutes. I did a lot of drawing on the bottom of the hair for shading. I began towards the top and then my pencil broke as I was sharpening it. I don't have anymore left. I brought snacks tonight.

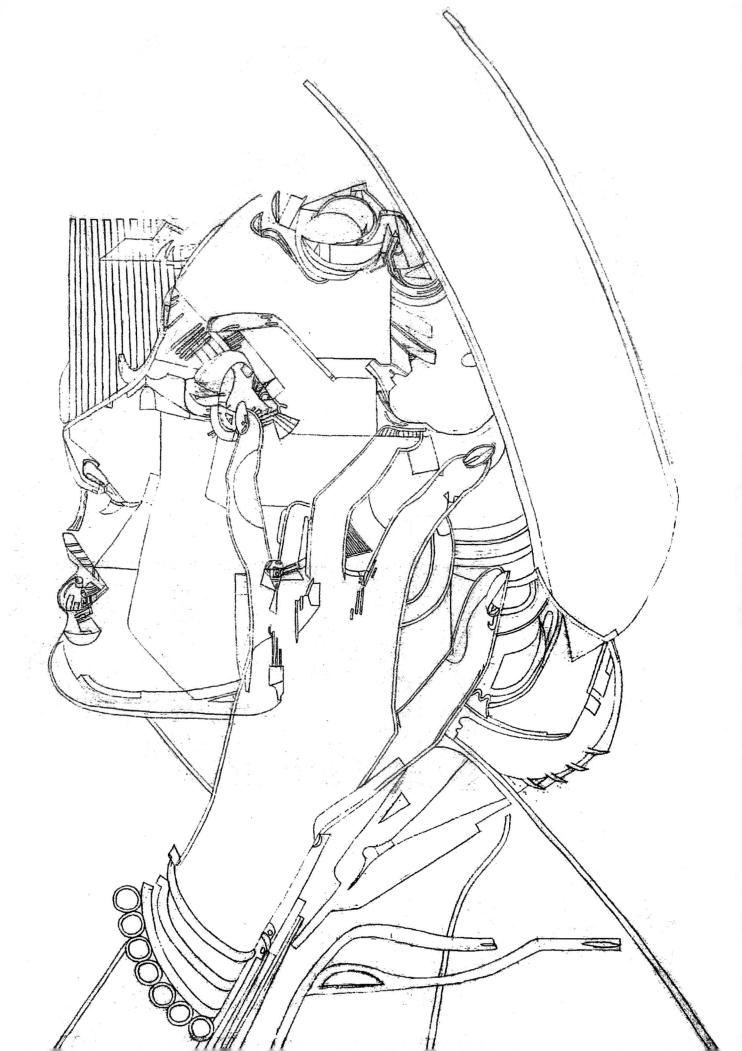

4/9/16, 9:05 p.m.—Walked for 30 minutes. I drew a lot of detail in the hair across the eye as well as above the forehead, which involves curls. I began to draw the leaf for the rose. I drew the hat, which included the outline.

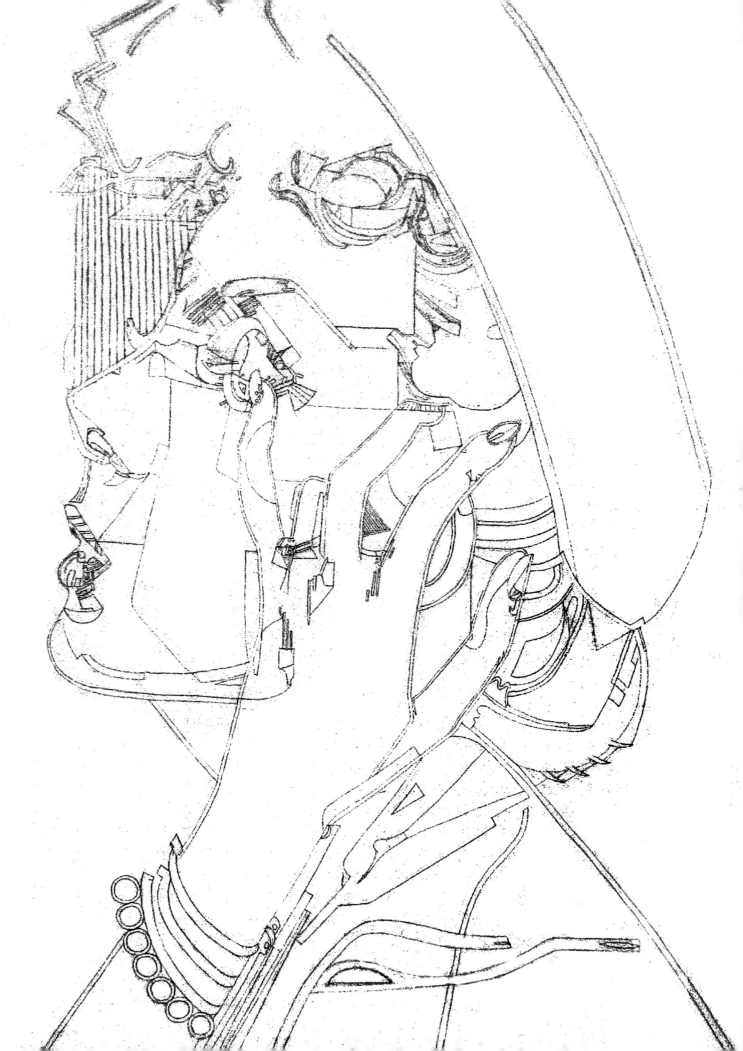

4/10/16, 9:30 p.m.—Walked for 30 minutes. I drew the other leaf and the bottom of the rose. I began to draw the outline of the rose. I noticed when I drew the last curl on the top that it was far away from the rest of the hair. I guess I'll just fill in the emptiness with a solid color.

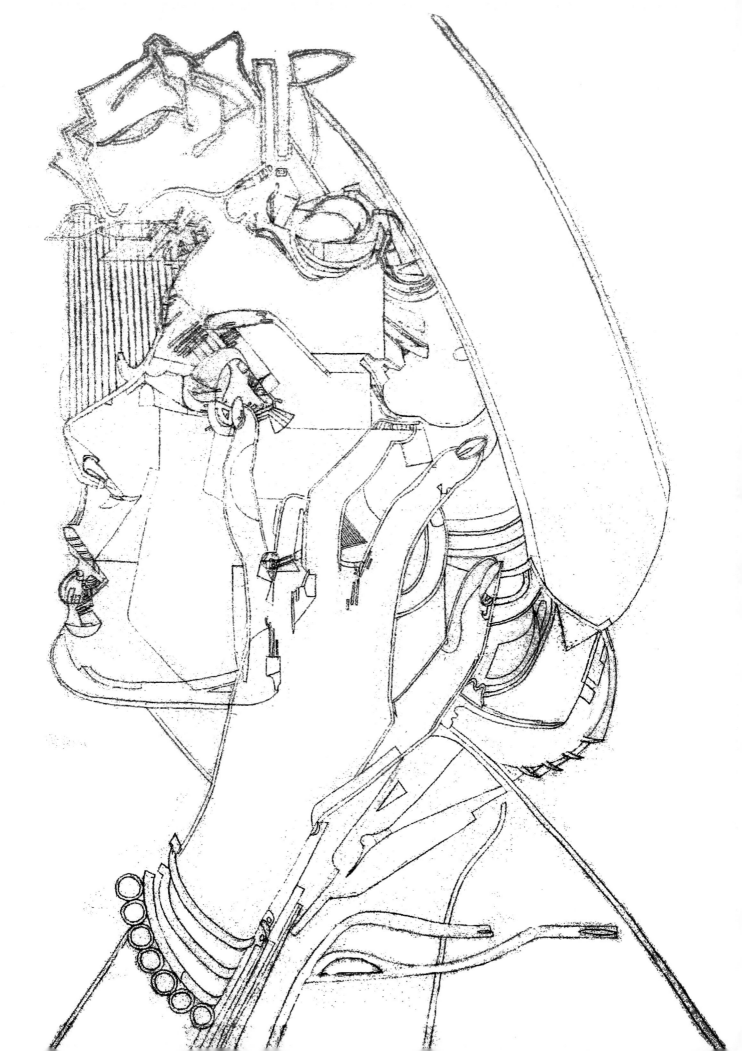

4/11/16, 9:40 p.m.—Walked for 30 minutes. I changed the location of the curl. I had to erase the crease of the rose and extend it. I began two leafs toward the top. I filled in the area between the rose and hair.

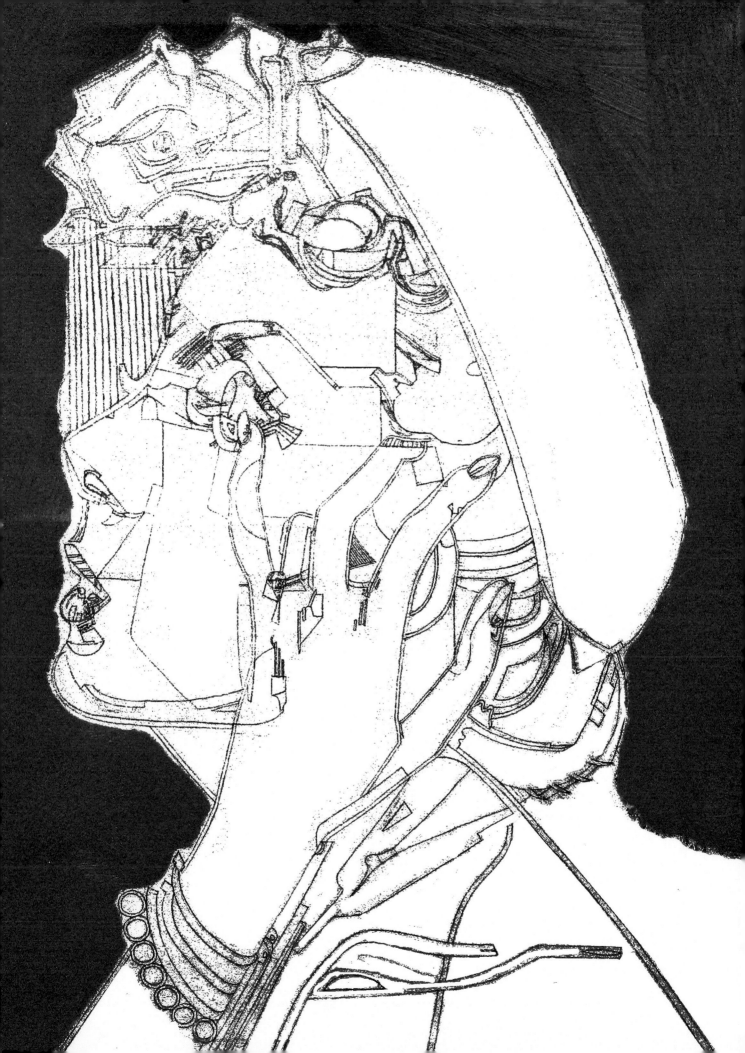

4/12/16, 9:30 p.m.—Walked for 30 minutes. I finished the flower and the leaf, so I was able to paint. It was like a wonder to paint. I used a big fluffy brush that reminded me of a powder brush. The paint went on nice and thick. It took a little while to cover the whole brush. Sometimes I had to pluck out the hairs that were sticking out. I almost finished the whole background. I used all the paint I put on the palette. The color is brighter than I wanted but looks lighter in pictures. I forgot to include the lipstick.

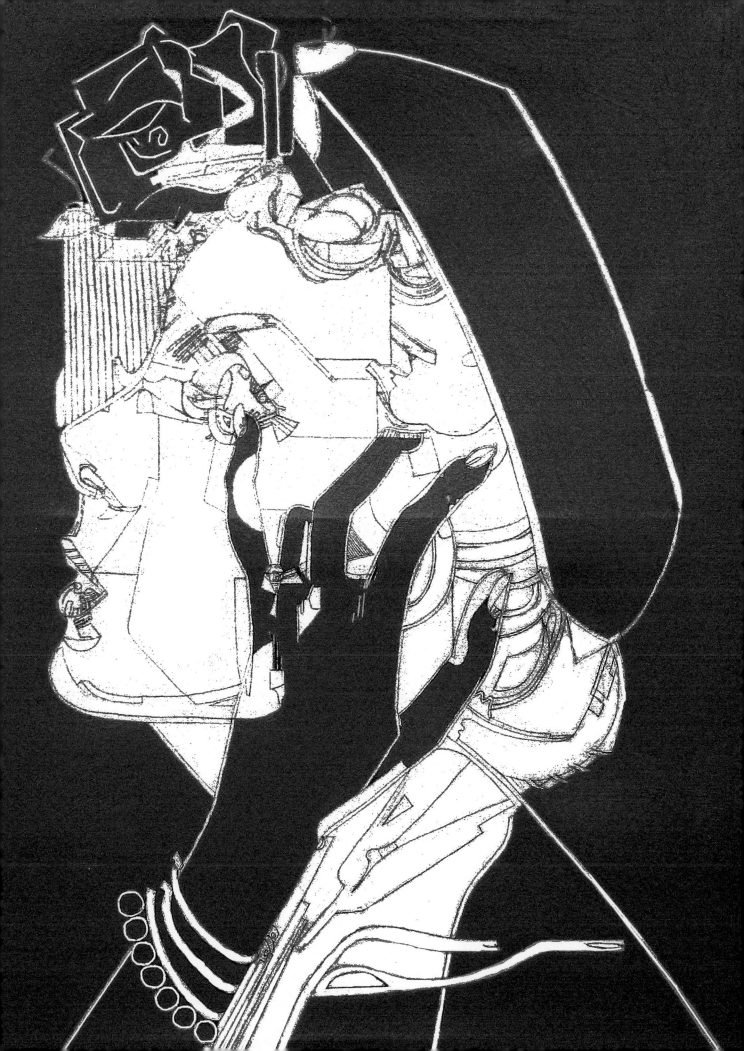

4/13/16, 9:35 p.m.—Walked for 30 minutes. I finished painting the bottom right corner. I painted the hat. I painted the hand and the arm. I painted the rose. I painted the right side and below it. Next I will paint the face.

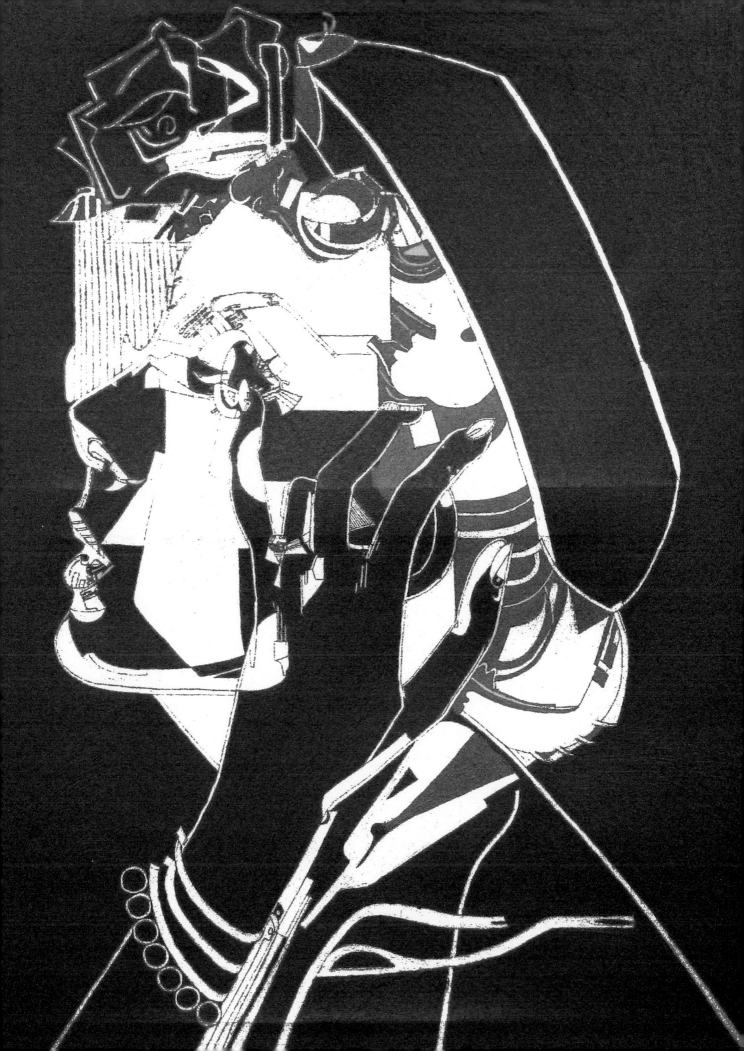

4/14/16, 7:20 p.m.—Walked for 30 minutes. I painted pink on the nose, around the lips, and on the chin. I also painted pink on the eye, around it as well as in it. I had some extra gray paint, so I began to paint the leaves and the hair. I also painted the ring and the shoulder.

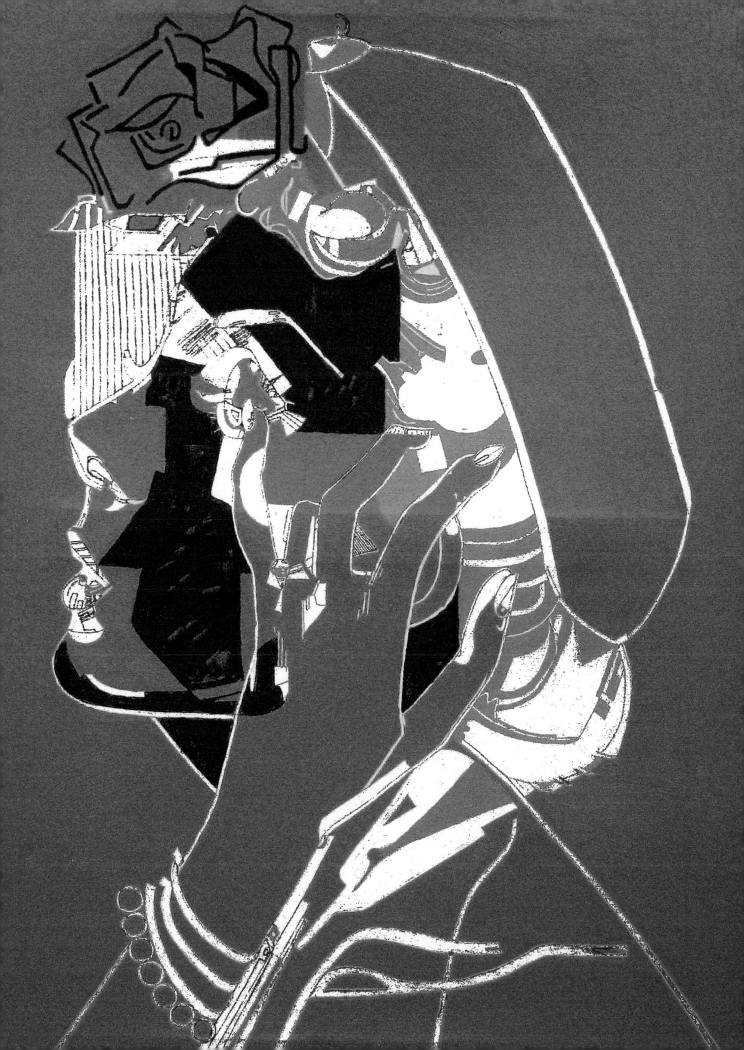

4/15/16, 7:30 p.m.-Walked for 30 minutes. Used the pottery pink paint, which came out deep and rich on the face and neck as well as on the hand. Next I used the pomegranate paint to outline the rose, because I wanted to see the contrast. It was almost like a black. It was difficult to paint on the face, because the paint wasn't even and I had to do coats in areas.

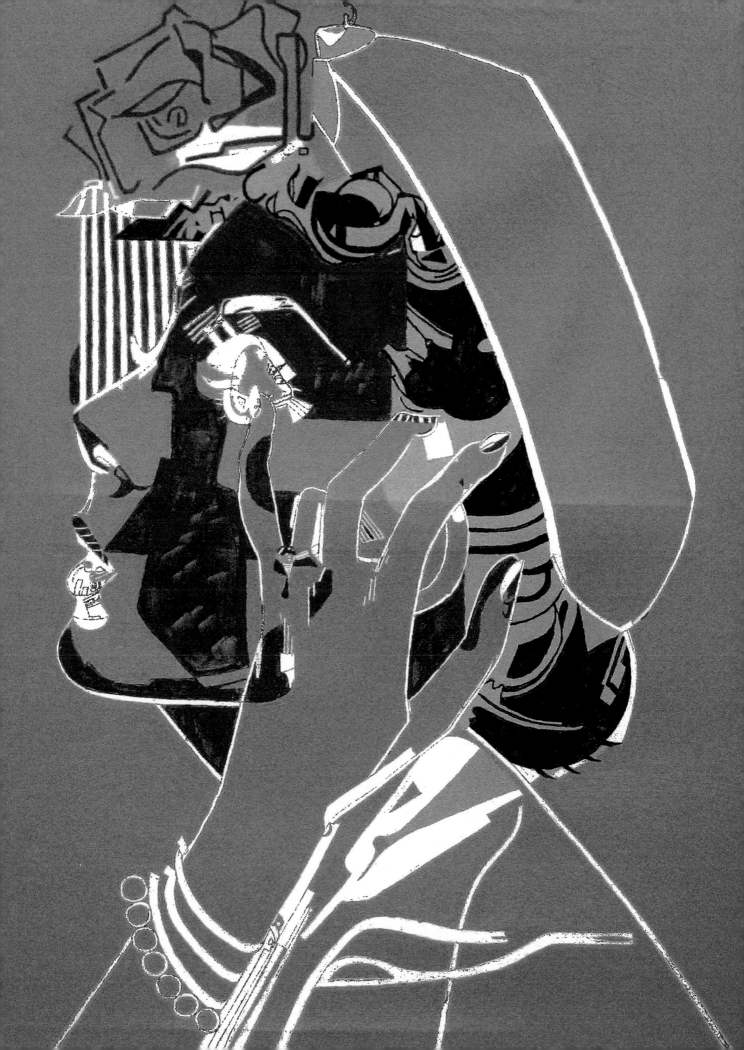

4/16/16, 7:10 p.m.—I used the pottery pink paint to create the lines near the eyelash. I also used it to fill in the bridge of the nose. I used it for the hands and the nails as well as for the nose. I put it on top of the ring and in between the fingers. Next I painted the hair black. As I was doing that on top the paint brush fell in the middle of the painting. I had to touch up the pink on the side of the face and the hand. As I was doing that I also touched up the lips.

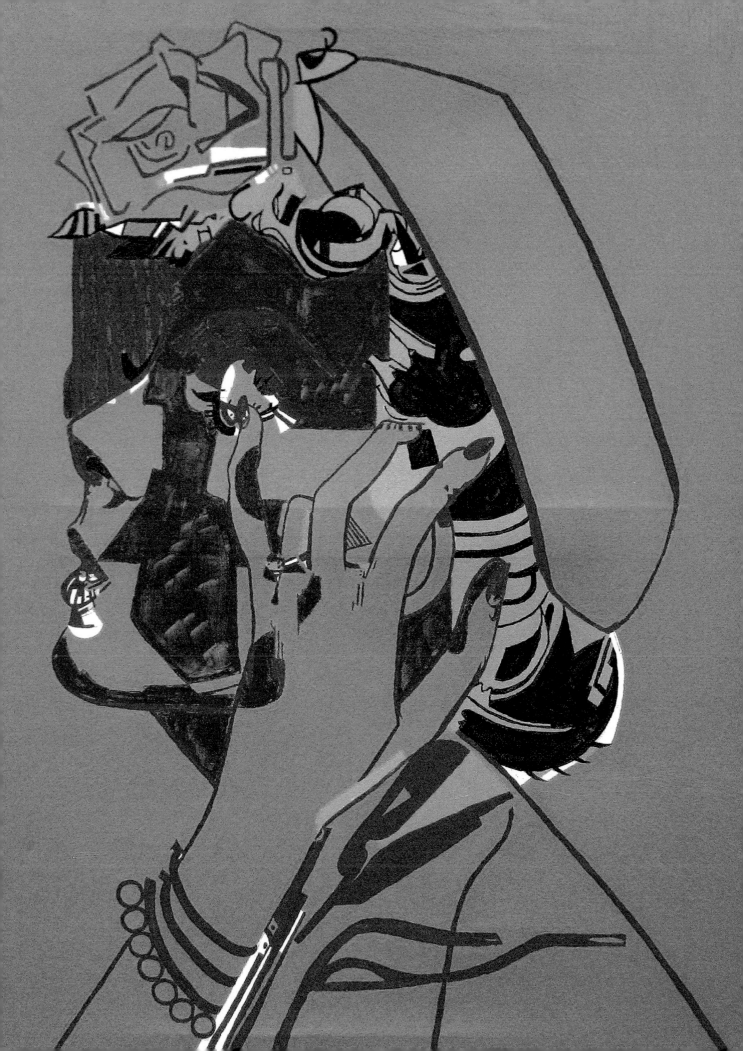

4/18/16, 7:20 p.m.—Walked for 30 minutes. Did video. I finished outlining with the Pomegrante paint. I filled in the lines near the eyelash with the same paint. I painted the bracelets as well as the shadows near the arm. I painted the lines on the face and on the hand. I used the black paint to paint the leaves, the eyelashes, the nose, and part of the hair. I also used the Pomegrante paint to fill in the lips and the ring. I used the gray paint to fill in between the fingers and the bottom of the hand.

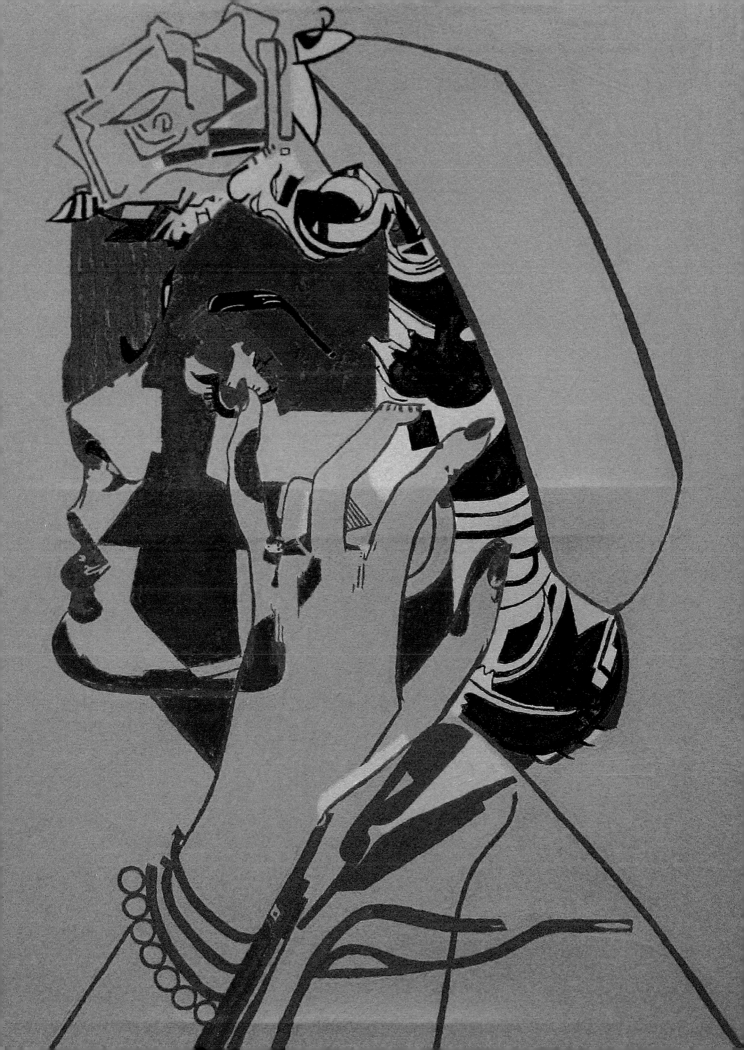

7/22/16-completed Cowl on Prince George's birthday. I was going to create more, but I decided to stop. I will associate it with the Taurus Astrology sign. I listened to Shakespeare's Romeo & Juliet by Tchaikowsky, who was born the same day as me, 4/25, where our "Colorstrology" color is Azure Blue. Oscar Levant's version of "Rhapsody in Blue" became the record of the year in 1945 after it was recorded on August 21, my parent's 50th Anniversary, the same year Disney World opened. George Gershwin's song is in "Fantasia 2000."

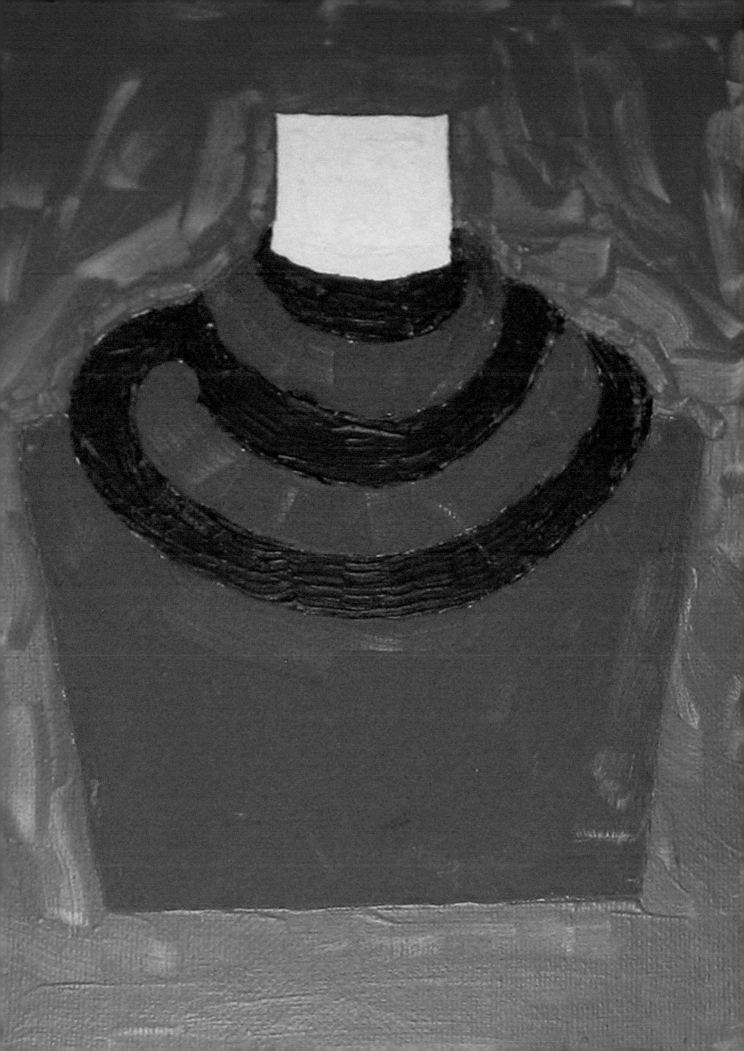

Printed in the United States
by Baker & Taylor Publisher Services